BICYCLES

Vintage People on Photo Postcards

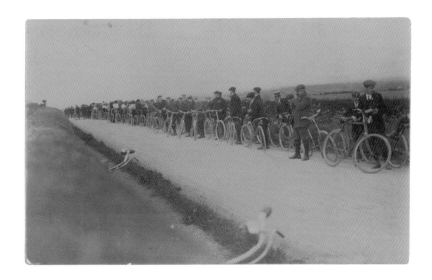

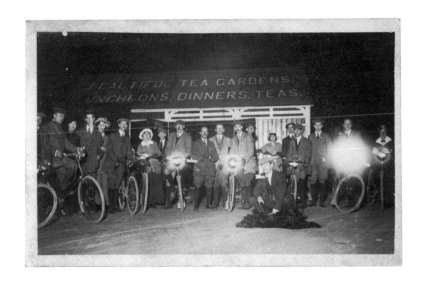

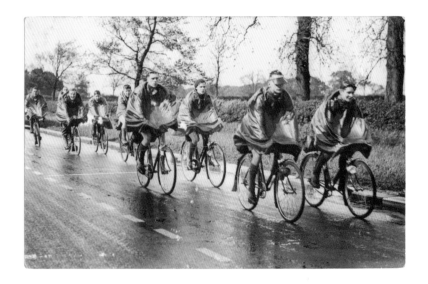

BICYCLES

Vintage People on Photo Postcards

Tom Phillips

Bodleian Library
UNIVERSITY OF OXFORD

for Patrick Hughes
artist with bicycle

First published in 2011 by the Bodleian Library
Broad Street
Oxford OX1 3BG
www.bodleianbookshop.co.uk

ISBN: 978 1 85124 368 6

So far published in this series; *Readers*, *Women & Hats*, *Bicycles*, *Weddings*.
Volumes forthcoming; *Men & Fashion, Fantasy Transport*.

Designed and typeset in Myriad Pro (10pt on 12pt) by Alice Wood
Printed and bound by Great Wall Printing, China on 157gsm 'Gold East' Matt Art
British Library Cataloguing in Publication Data
A CIP record for this publication is available from the British Library

FOREWORD

William Fotheringham

When it comes to publishing cycling postcards, I can claim a little experience, of a kind. In the mid 1990s at *Cycle Sport* magazine we briefly ran a backpage feature entitled *Postcards From Hell*, a mix of the embarrassing, strange and simply naff portrait cards professional teams print as souvenirs for the fans. 'Glory cards' one pro racer nicknamed them, for the simple reason that posing clumsily bike in hand against the first backdrop that could be found marked the zenith of some cyclists' careers.

What follows in these pages is in an entirely different register, however. Produced in tiny print runs from photographs taken by local studios or street photographers, these cards provide a series of snapshots of a period when Britain, in common with much of the industrialised world, was as heavily reliant on the bicycle as we are now dependent on the car. This era, 1903 to 1950, was the heyday of cycling, beginning when the bike itself became a mature product at the end of the 19th century, and ending with the rise of the car as post-Second World War austerity gradually receded.

The bicycle was ubiquitous, a tool that enabled retailers to get their products to their customers, mail to arrive at households around the country. As the cards reveal, it featured on stage in circus and black and white minstrel shows and it was an object treated with something approaching worship. In the pages that follow there are children posing solemnly with what must be their first 'adult' bikes, the receipt of which was presumably a rite of passage similar to passing the driving test today. The bike was decked out with flowers for village fetes and was a vital prop in fancy dress parades, the equivalent of today's four-wheeled carnival float.

If the bikes in these postcards appear to vary little, that is down to the fact that the machine itself altered little once the basic form of diamond-framed safety bicycle with chain drive and pneumatic tyres had emerged at the end of the 19th century. Even now the utility bike, still sold in its hundreds of thousands, has in fact barely altered in the last hundred years apart from improvements to some of the materials. Stand by any roadside in Holland or Denmark today and you will see upright-framed, heavily tubed machines with skirt guards made of fanned-out strings, going past you one after another. That is testimony to the ability of cycle makers during the 'bike mania' of the late

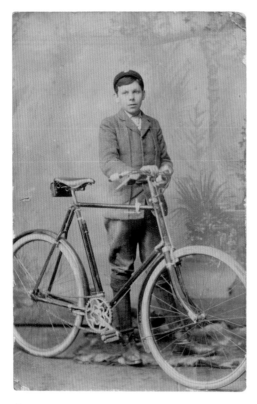

4

and Brooks saddles, both of which have been in production since the pioneering days of the 1880s.

It is easy to forget the social impact of the sudden discovery of personal mobility that accompanied the development of the bike. Suddenly personal life and independent commerce were no longer constrained by the distance a person could walk in a given time or by the wherewithal to keep a horse. What shines through in these cards is the pride people felt in their new-found ability to go further than before, and get there faster. It spans all ages and all classes: elegant ladies in finely crafted hats, young lads on their tandems, the milkman with his buckets, the postwoman with her bag, young couples, families, schoolchildren, scouts, sailors, racers with their trophies, cycling clubs with their capes and outdoor cafes. It was that pride that led them to pose for the photographers, sometimes in front of romantic backdrops of dreamy castles and garden steps in local studios, or in the street and in front of their workplaces. These pictures all say one thing: this is me, this is us, with our bikes.

The images connect us down through the generations. The heavy diamond frame with leather saddle, straight handlebars, sturdy mudguards and rod-connected brakes was the kind of machine my grandfather used

19th century, when bike design advanced from Starley's original 'safety bicycle' to the relatively mature product of the early 20th century. Lest we forget, these bikes were the centre of a vast industry, largely based in the West Midlands, traces of which can still be seen today: it's a fair bet that some of these postcards show Reynolds tubing

it from the utility machines which were, of necessity, built to last. Something along these lines was the life-changing birthday present I received as a 13-year-old. At one time or other, most of us have shared some of the pride these people clearly felt on two wheels, in mobility, independence, comradeship and exploration. The cards are very much of their time, but in that regard, they are truly timeless.

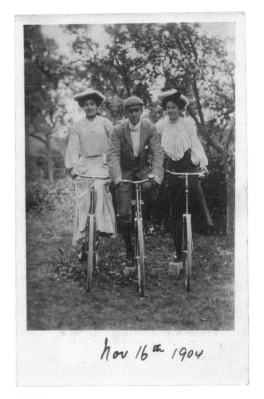

nov 16th 1904

5 1904

to ride the 100 miles from Birmingham to Pangbourne when he was courting my grandmother. It was this sort of bike that my father rode up and down the pitheaps of north-east England as a kid, and that he used to explore the moors of the Scottish borders before he moved on to what was then known as a 'lightweight', to distinguish

INTRODUCTION

Tom Phillips

I loved my bike, or rather I loved my brother's metallic-red Norman *Invader* which, gleefully adopted when he was called up for National Service in 1951, offered two years of cycling to museums and distant bookshops. It also got me racing. A group of classmates held a time-trial from Clapham to Brighton, a fifty-mile run. We set off at monitored intervals, then, eyes down, noticing nothing, pedalled towards the photo machine on Brighton pier which for sixpence yielded a grainy photo stamped with the exact minute. I never matched the times of the keenest with their stripped down bikes unencumbered by mudguards or saddlebag, but my own record of 2 hours 37 minutes was considered not bad for an arty swat.

I see that past self imaged in this book; certainly as one of those awkward schoolboys in 89; and later among that earnest group (3) on its weekend club outing undaunted by rain, when I was briefly attached to the Tooting branch of the CTC (Cyclists' Touring Club). I joined one summer but, when winter came, I discovered myself to be a fair-weather biker with little taste for the hearty camaraderie of the meeting hut or for cycling towards sodden picnic spots against a biting wind.

University saw the end of my cycling years. Oxford was a little too far and hitch-hiking was easy. Art school, in Peckham, was only yards away, and I would never have cycled again save for a late romance with a dedicated cyclist. I bought a Claud Butler (magic bike name of my youth) then graduated to an eggshell blue Bianchi, with Campagnolo gears. Eventually the cycling siren vanished and with her, mysteriously, my bike.

Though I can no longer cycle, and look with envy at the racks of Boris bikes appearing all over London, I still feel kinship with these proud presenters of their machines.

By the 1880s the 'safety bicycle' and pneumatic tyre made all older forms (like the penny farthing) redundant. The rhomboid geometry of its frame remained in essence the same throught the 20th century, and even now a person riding by on a bicycle a hundred years old would turn no heads.

Connoisseurs of pedal, sprocket and lug will of course notice here many arcane details as well as the often elegantly crafted look of

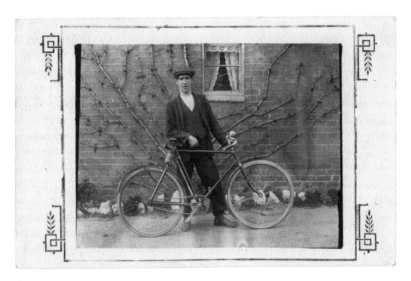

6

lamps and accessories. But generally a bike is a bike is a bike.

One big difference between past and present escapes photography. Their sheer weight, with thick tubing and sturdy components, made the old machines a heavy lift. Even my *Invader*, in its day a lightweight sporting model, was a considerable heave. The Bianchi was half its weight and my neighbour's new bicycle can be lifted with the little finger.

Also eluding the black and white camera, so good otherwise at uniting the atmospheric with the particular, is colour, for bikes were not uniformly black. Ladies' cycles often came in vivid colours like that of Emma, Thomas Hardy's wife, who nicknamed her bright green machine 'The Grasshopper'.

The vintages of people can, however, be more readily identified. Costume, context, even stance, announce the shifting decades.

Apart from the short-lived Victorian fashion for bloomers, women, helped by chain protectors and skirt-guards, yielded little in formality of dress until after the First World War. Even the obligatory hat was not left behind, with the larger creations

secured to the head with a scarf (76). Only half way through the century would one see a woman in trousers riding a man's bike (26). Men on the other hand, as can be seen, tended to use the alibi of sport and excercise for greater sartorial eccentricity.

Sorting through hundreds of cards of people with bicycles I gradually realised that women actually outnumber men. Eager to be acknowledged as bicycle owners they are proud to display their often gleaming new machines. A man's bike, with more prosaic associations, was somehow less flauntable.

The freedom granted by the bicycle transformed the lives of landed and working-class women alike, making them lone travellers for the first time. What chaperone, even a Wodehousian hawk-eyed aunt, could keep up with a fit and wilful girl on a bike pedalling to places of her own choice and companionships hitherto forbidden?

These liberating pleasures were only one aspect of the role of the bicycle in women's lives, which had been augmented by the independence gained in the taking of vital jobs in factories and in the service industries during the First World War (e.g. the postwoman in 184). Susan B. Anthony the prominent suffragette had written as early as1896 that *the bicycle has done more to emancipate women than anything else in the world*. Christabel and Sylvia Pankhurst were both members of the still extant *Clarion* cycling club founded by the socialist newspaper (see *Readers* 195) which once boasted 7,000 members.

The male could adapt to his mount by the simple expedient of cycle clips, touchingly immortalised in poetry by Philip Larkin (*Church Going*). The guest appearance here (174 & 175) of two individuals with no bicycle in sight advertises how they arrived at the photographer's premises . As with so many cards the narrative possibilities are rich, since one of the pleasures of examining them is the imagining of events before or after the photographs were taken. Sherlock Holmes himself based many of his deductions on an element that was absent. Here he would have to determine in each case whether the man took no pride in his bike or the studio was up stairs too narrow to allow a bicycle to pass.

It is H. G. Wells in Edwardian times who was the prime chronicler of the joys of cycling and the possibilities of romance it provided. *The Wheels of Chance* celebrates a liaison that came of the new freedom, as does his better known *History of Mr Polly*. The couple in 21 conjure up perfectly the rakish Mr Polly and his prize (the presence of two

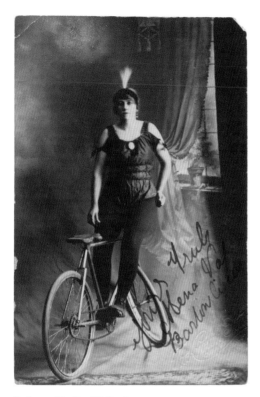

7 Crown Studios, Wellington

Frequently we see cyclists posed before some stately home or its grounds. Are we to suppose them the owners, or just visiting? The permutations of person and backcloth are endless and often entirely random as in the case of the poor chap about to be engulfed by a tidal wave (31). The trick cyclist (7) must have felt that the atmosphere of the Big Top had not been quite conveyed by a drab room with a prosaic flower pot on its window sill. Some backcloths slowly grew indecipherable with cracks that came from repeated rolling (84). No one seems to have minded and, more often than not the background announces its fiction by an abrupt end at floor level.

Occasionally, however, the illusion is carefully maintained. It is hard to spot at once that the racer in 195 is *not* careering down a winding road. The backcloth bends uninterruptedly to the image edge while the pedal's support is masked by some tricky stippling of the negative.

Nothing, however, quite transmits the beckoning of the country road as the real thing (118 & 120). Nor is any studio set up as intriguing as the unknown narratives behind what anthropologists would call, often appropriately, a field photograph. The perennial problem is the identity of the photographer. In a group he or she is accounted for by the extra bike in

bicycles is shown by the merest glimpse of her wheel). Perhaps the more enduring encounters might have led to marriage (39) and a tandem, their two bikes, so to speak, joined in welded bliss.

The scenic pleasures of cycling could be hinted at by the studio photographer.

the background telling you that this trio is actually a foursome. Certain photos are identified as being the work of the representative of Sunny Snaps (182 & 183) or a regular street photographer, but could the complacent well-posed man in 27 be a delayed action self-portrait? Photo postcards abound in such inconsequential enigmas.

Cycling as a sport commands a more formal approach, the standard images being either the mounted champion, with trophies well in view, or the rehearsal of a racing start with the trainer ready to launch the fixed-wheel rider into action. Most commuters nowadays ride bikes similarly stripped down, as if mud had never been invented.

The opposite was the garlanded machine (147) decked out with flowers and ribbons which competed for prizes in fund-raising fetes. While nothing is too minimal for the racing cyclist, abundance is the watchword for the parade, with the cycle itself scarcely discernible (or one supposes, rideable) under the mass of real and paper flowers, indicating serious competition ahead.

The small wheeled bikes ridden by children (95) oddly foreshadow the modern foldaway. The tricycle is inevitably the beginner's version and even, occasionally as in 128, the chosen form of locomotion for the aged or invalid. The fine tricycle of 65 with its high wheels and hard tyres looks to be the oldest machine in this book.

Now, once again fashionable and classless (good enough for a prime minister, good enough for you), the bicycle is an increasingly common and healthy sight with designated paths, and a bunched *peloton* ready for the off at every traffic light. How to capture though that first fine careless rapture of the Edwardian cyclist? Ken Russell achieved it once in his film about Elgar with the young composer riding through the Malvern Hills to the music inspired by the match of that landscape with the pulse and rhythmic motion of his trusty bike.

Note

All the cards are real photos taken directly from glass or film negatives. Though reduced to 75% of actual size , they are shown as found with only the occasional adjustment of border, contrast, or the removal of a distracting blemish. The captions give the date (where known) and the name (if provided) of the photographer or studio. An occasional attribution to 'Jerome' or 'USA Studios' for example is to a nationwide chain of studios or processors with no particular location. An asterisk indicates that further information is provided in the notes. A general commentary on the history and essence of the photo postcard can be found on p110.

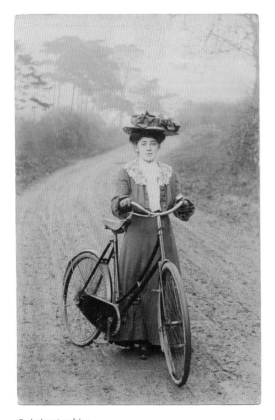

8 Leicestershire

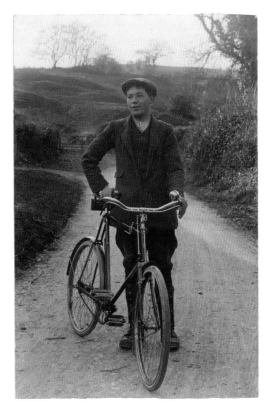

9

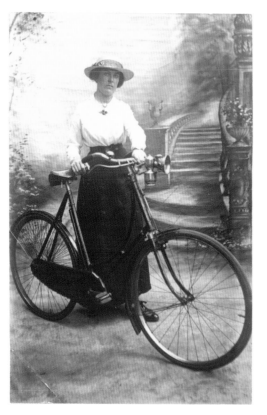

10

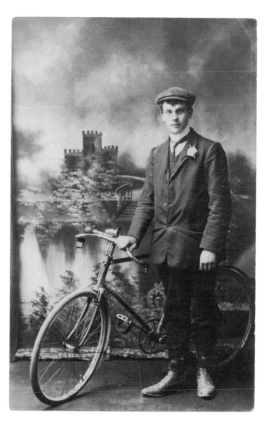

11

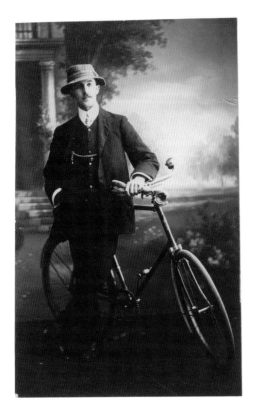

12 1908, Worksop

*

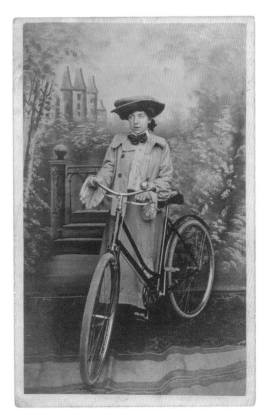

13 Whitnash

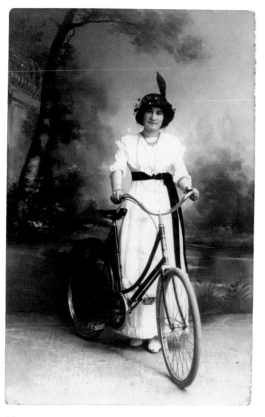

14

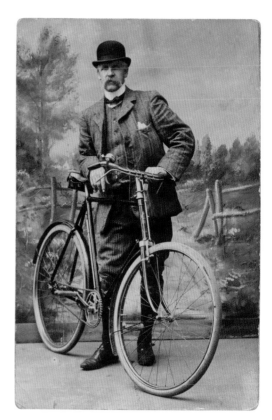

15

16

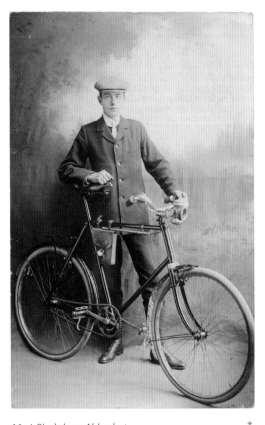

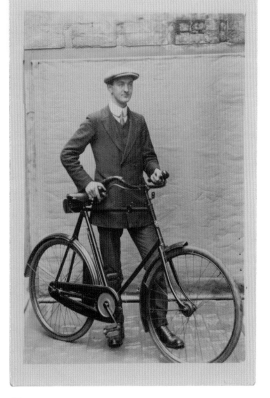

16 J. Blackshaw, Aldershot * 17

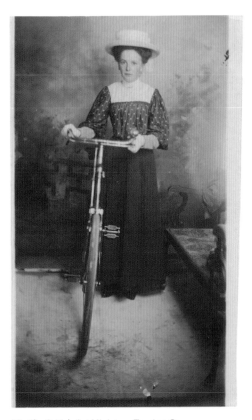

18 The British Art Miniature Touring Co.

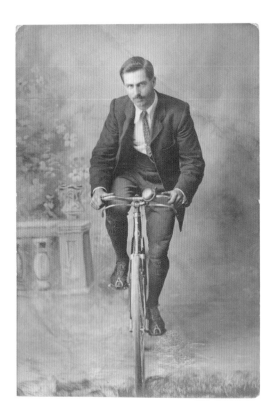

19

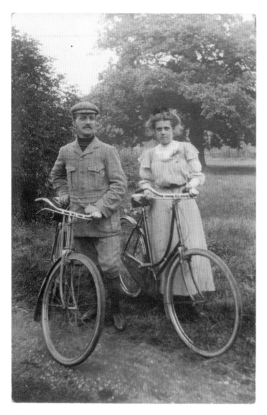

20

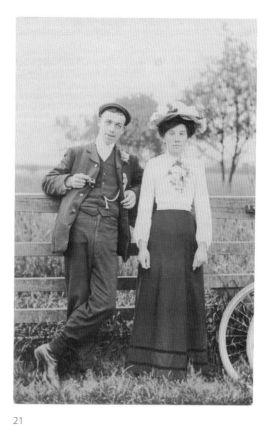

21

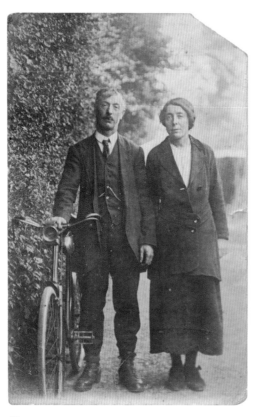

22

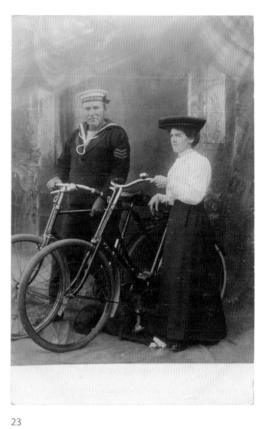

23

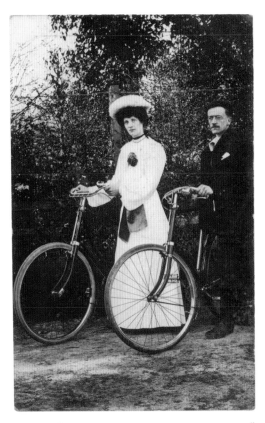

24 1906, Battersea

*

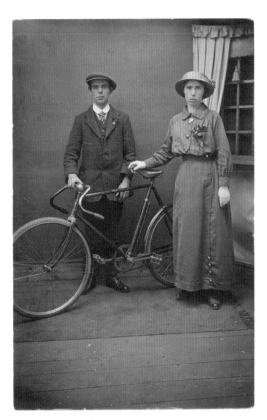

25 W. Cooke, Kidderminster

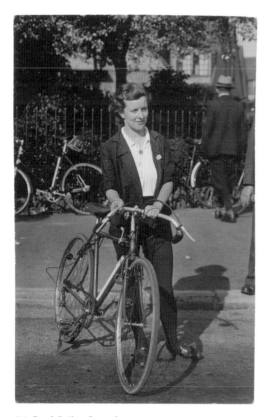

26 Frank Bailey, Canterbury

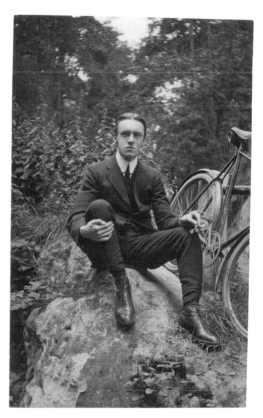

27

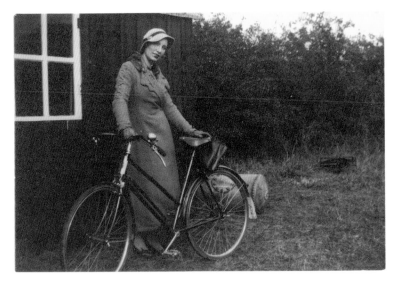

28

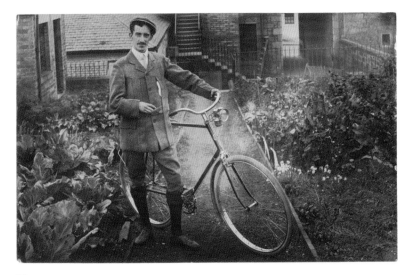

29

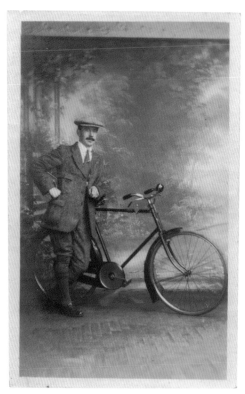

30 W. Wild, Birmingham

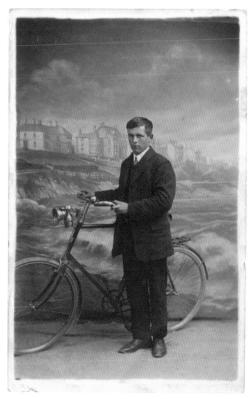

31

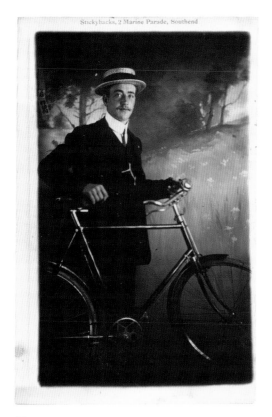

Stickybacks, 2 Marine Parade, Southend

32

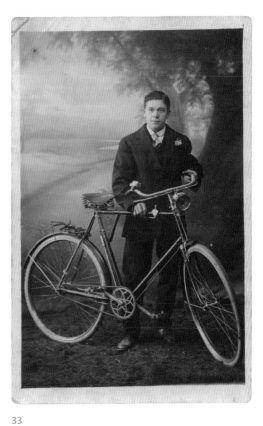

33

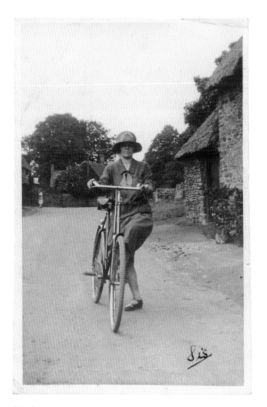

34 Jerome

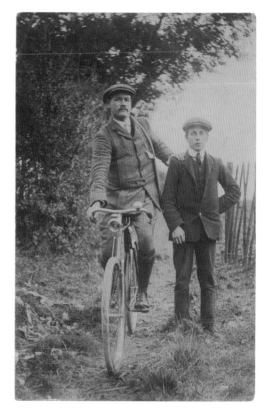

35 1910, Fareham *

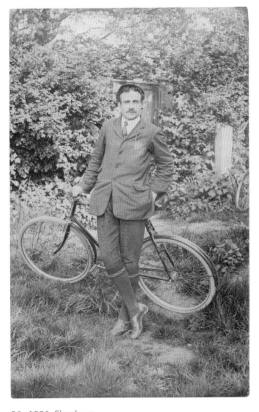

36 1906, Chesham

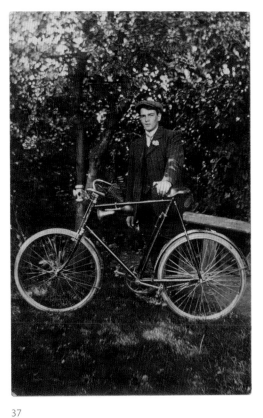

37

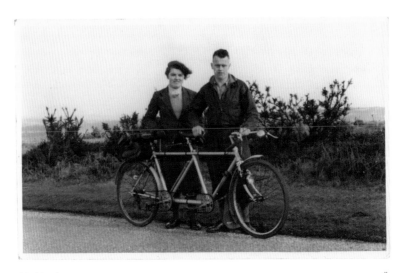

38 Horsham　　　　　　　　　　　　　　　　*

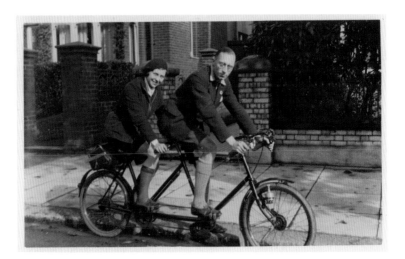

39　　　　　　　　　　　　　　　　　　　*

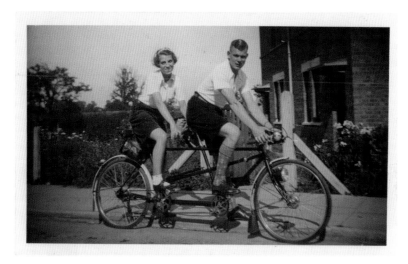

40

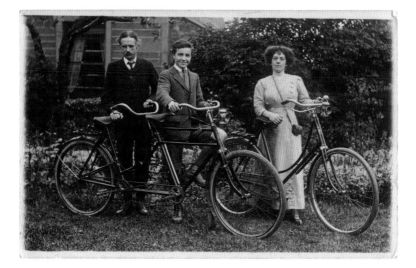

41

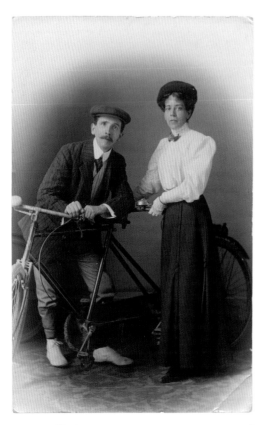

42 1910, Ilford *

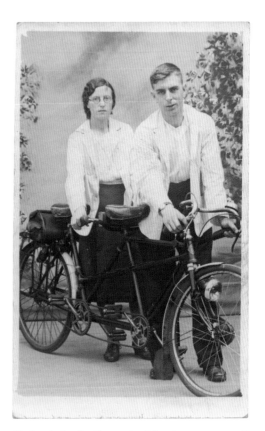

43 Scenic Studio, Pleasureland, Southport *

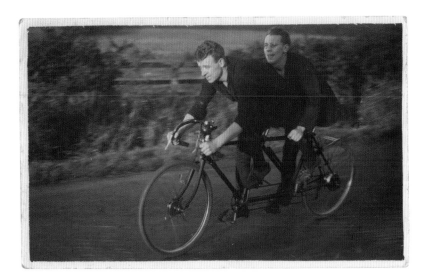

44 John B. Redley, Hexham *

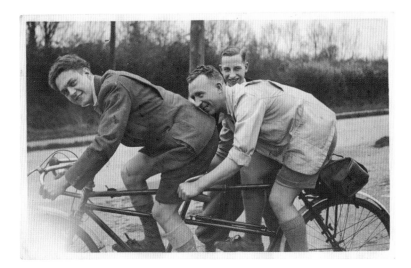

45 Maldon *

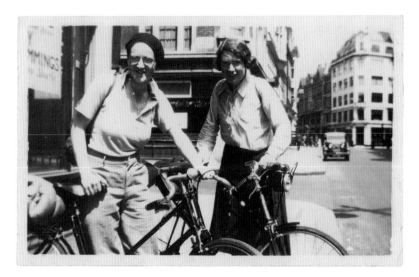

46

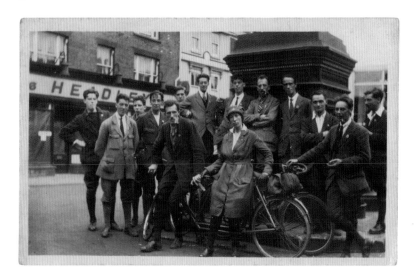

47

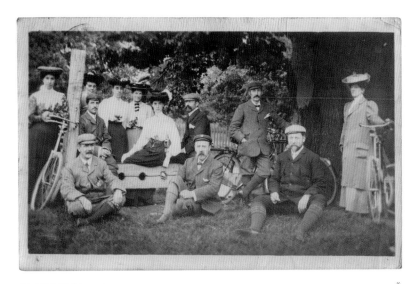

48 1907, Walthamstow *

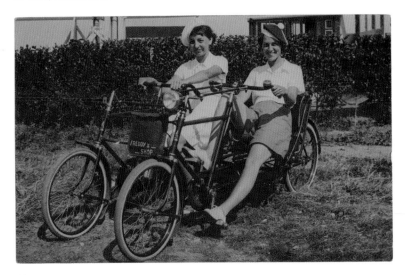

49

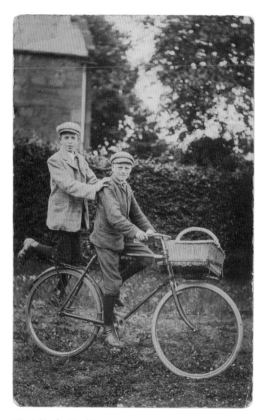

50 J. Steele, Brechin

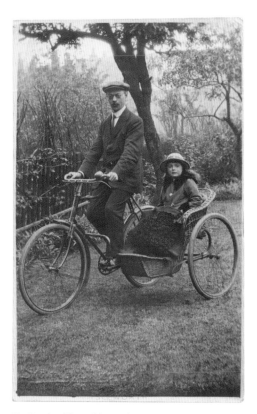

51 Stanley Nixon, Isleworth

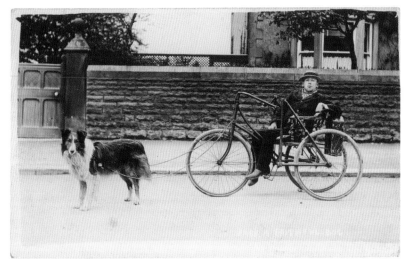

52
*

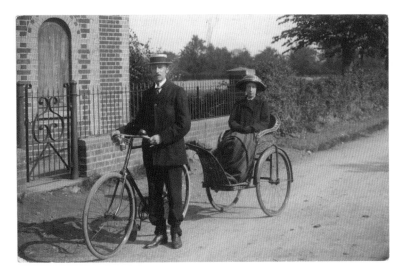

53

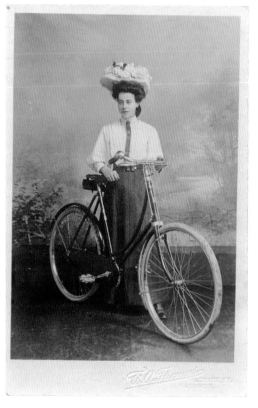

54　W. A. Thomas, Hastings

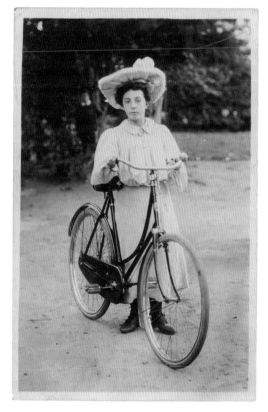

55

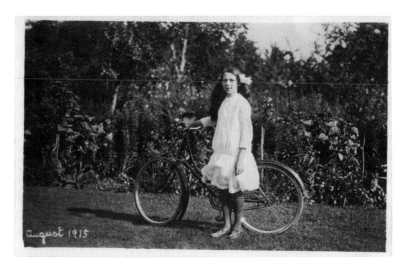

56 1915

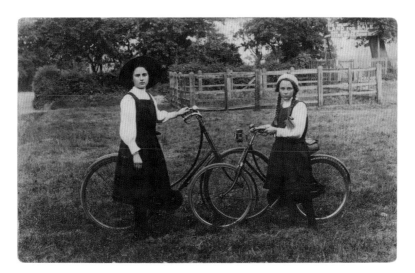

57

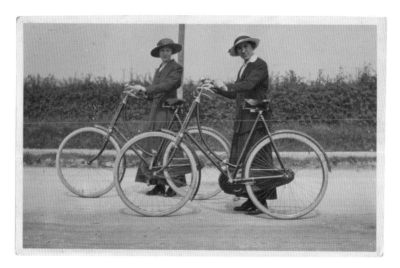

58

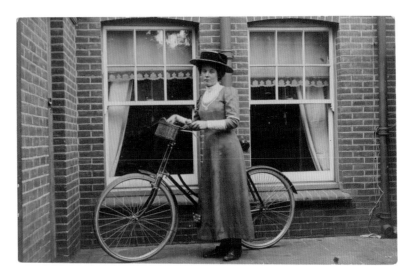

59

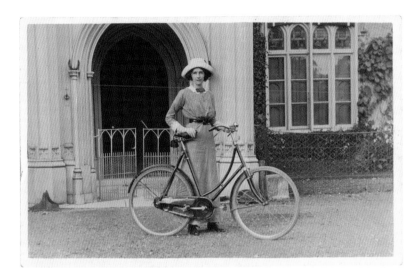

60 Long Stratton

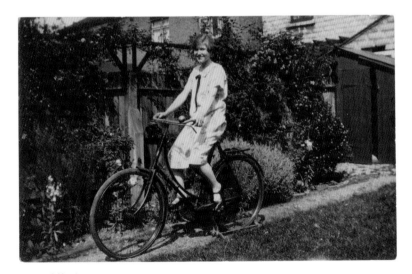

61 Guildford

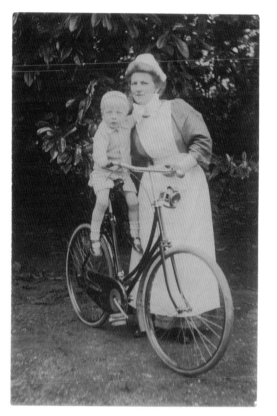

62

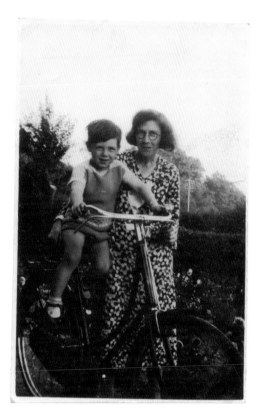

63 Jerome

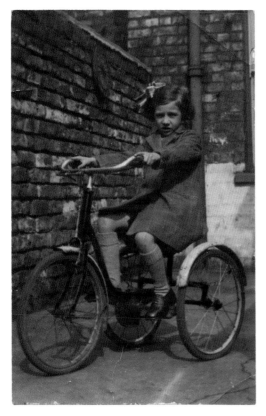

64

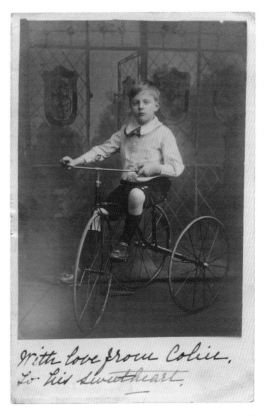

65 1915, Wallasey *

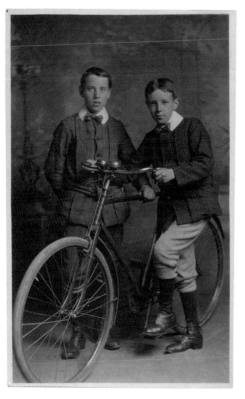

66

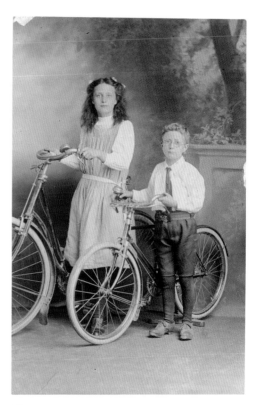

67

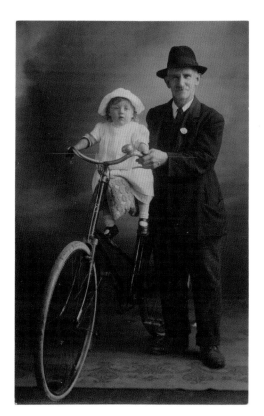

68 P. Burtonwood, Kendal

69 Ipswich

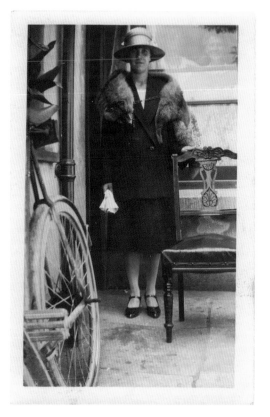

70

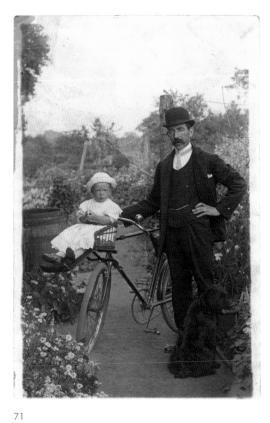

71

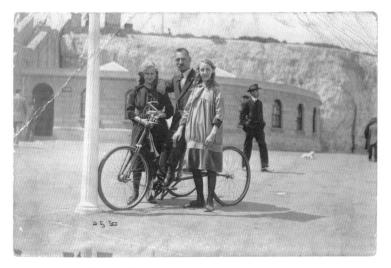

72 M. & S. Photo, Westonville

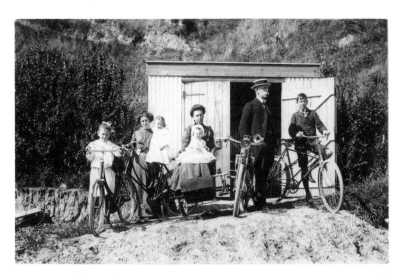

73 1910, H. Billens, Palmerston *

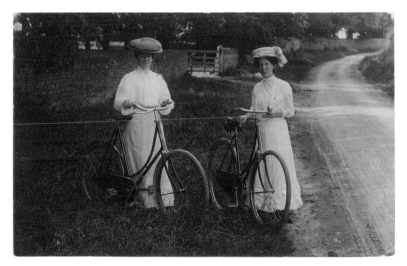

74

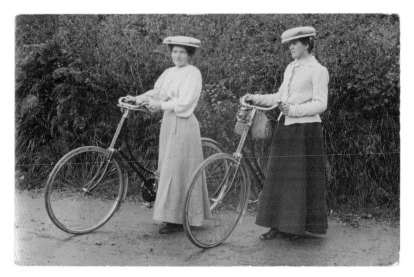

75

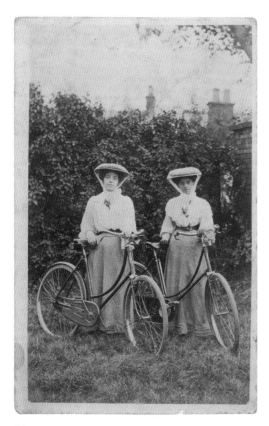

76

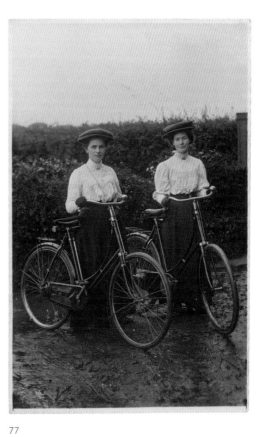

77

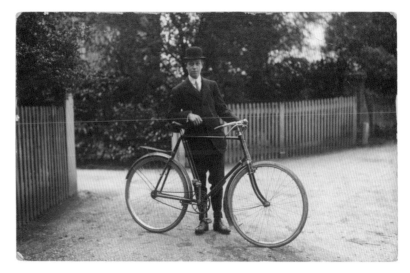

78

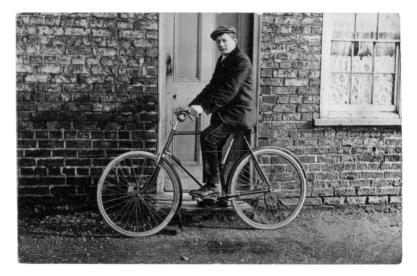

79

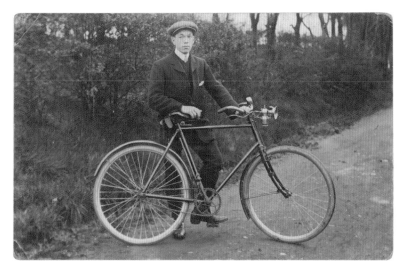

80

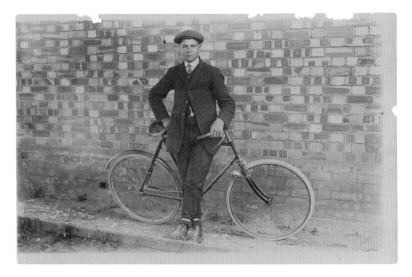

81

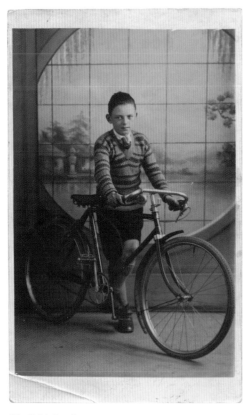

82 Gale's Studios

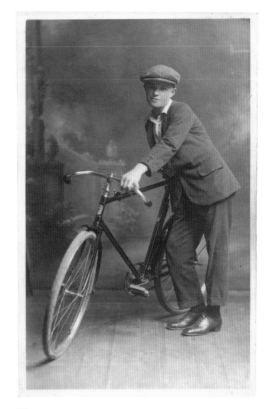

83

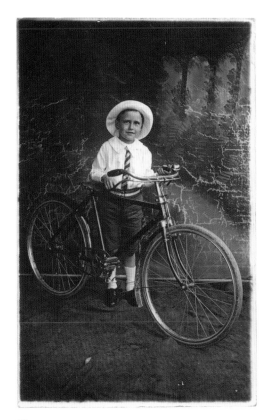

84

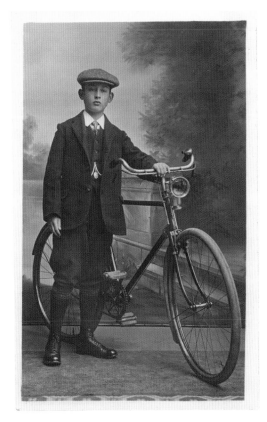

85

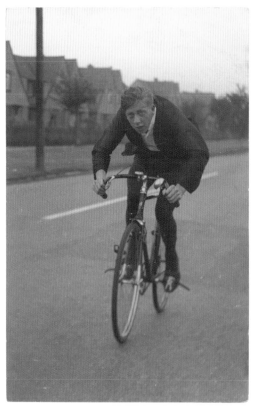

86

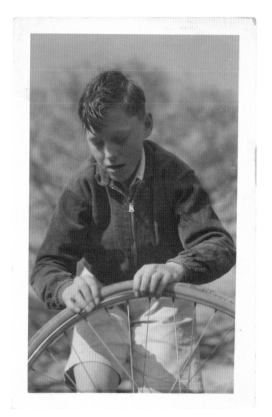

87

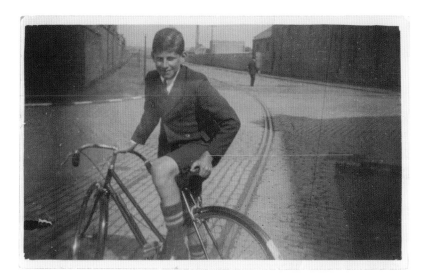

88

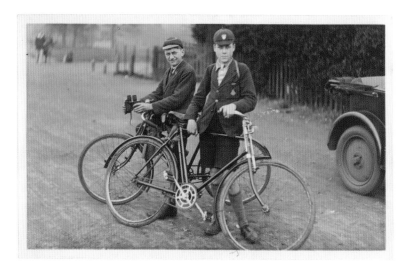

89 Alex H. Low

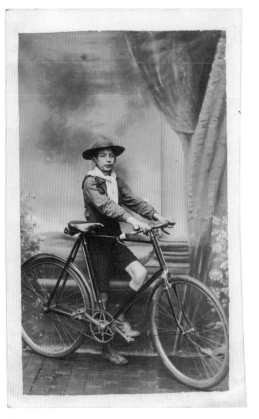

90

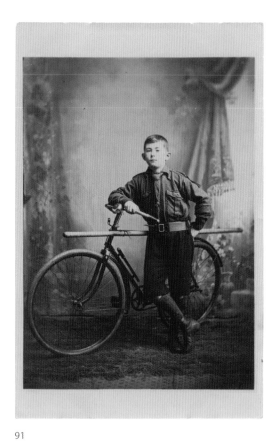

91

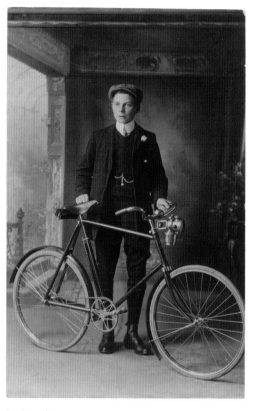

92 Lincoln

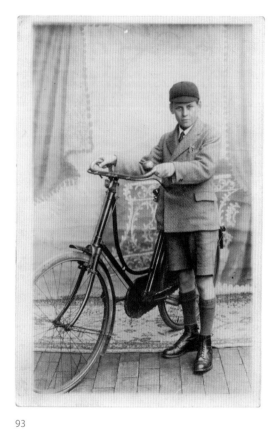

93

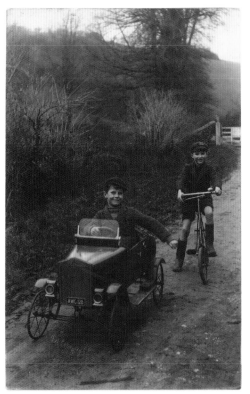

94 1927, Wallace & Sons

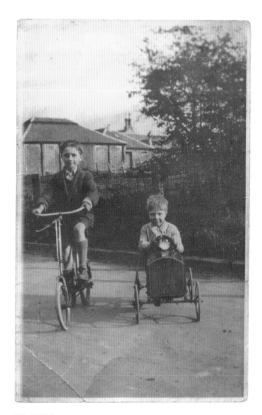

95 1928

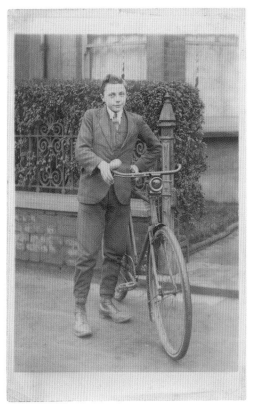

96

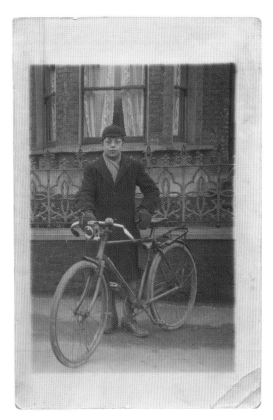

97

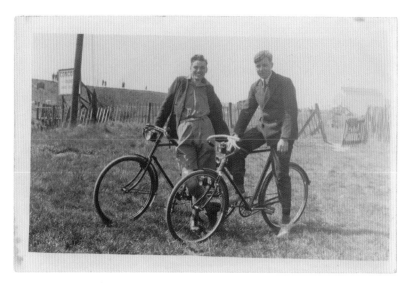

98

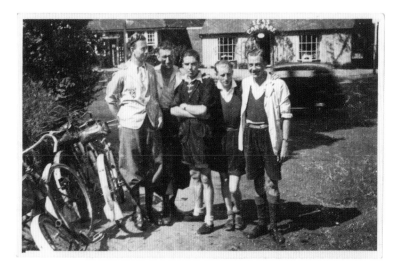

99

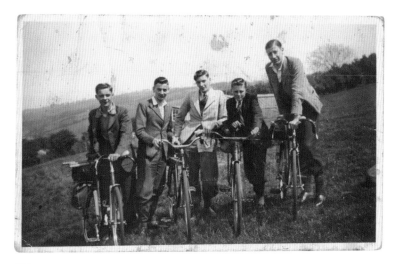

100

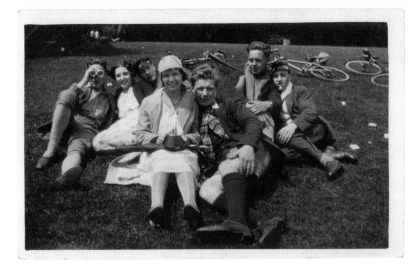

101

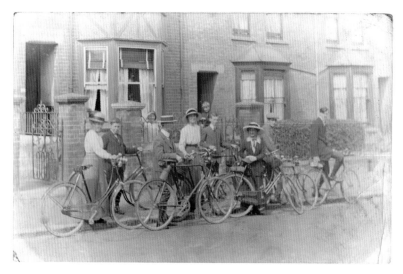

102

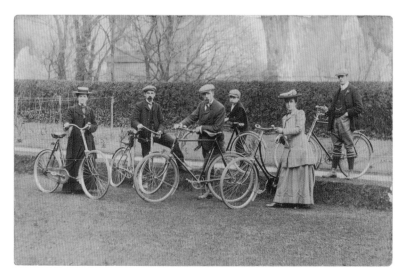

103

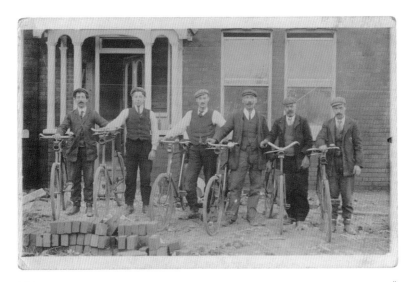

104 *

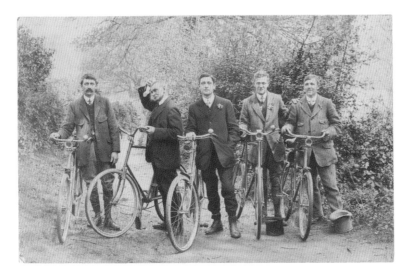

105

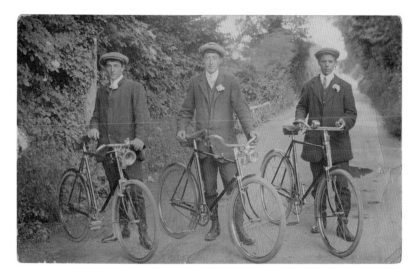

106

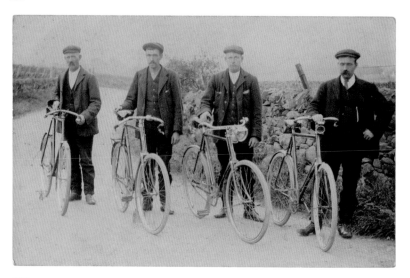

107

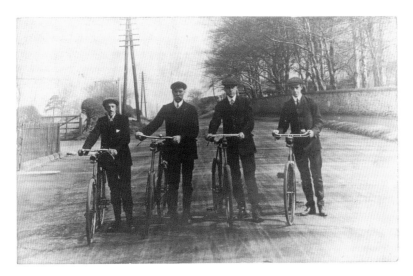

108

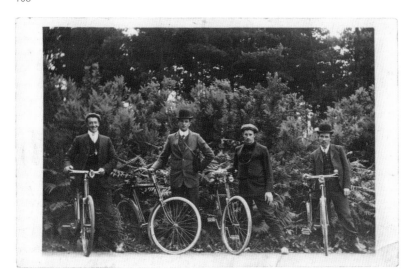

109 Gale & Polden, London

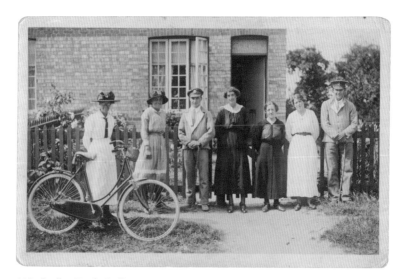

110 Cradley Heath, Staffs.

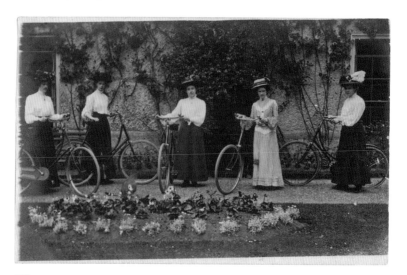

111

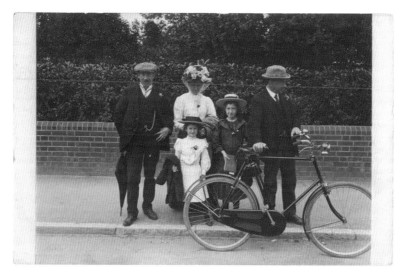

112

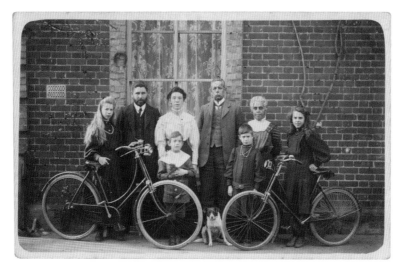

113 F. J. Mott, Ongar

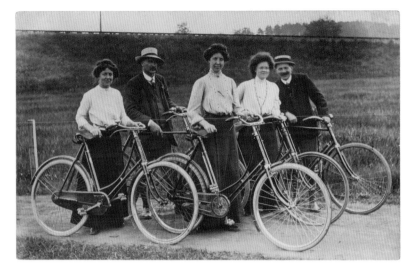

114

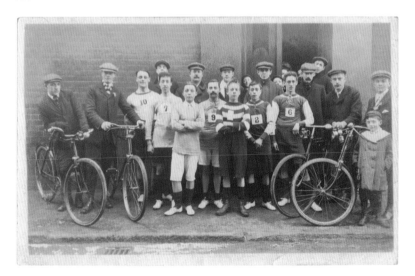

115

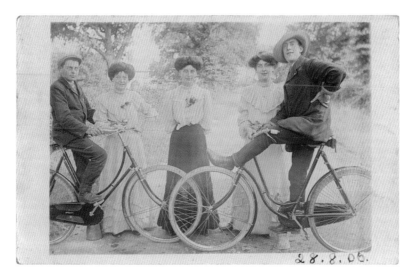

116 1906, Cambridge

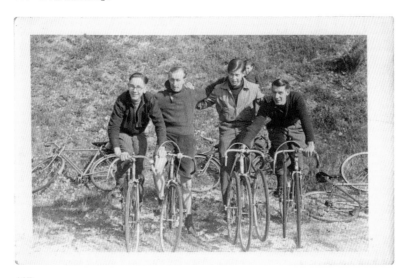

117

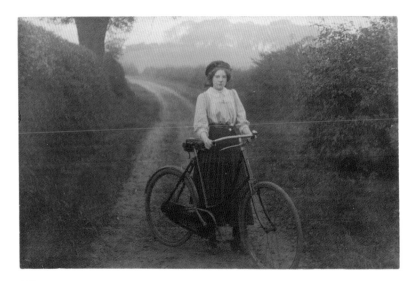

118

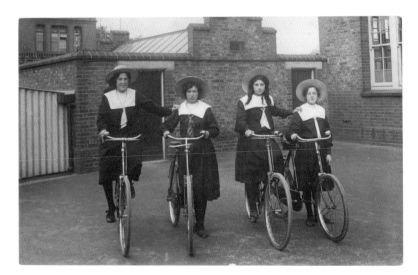

119 Ambleside

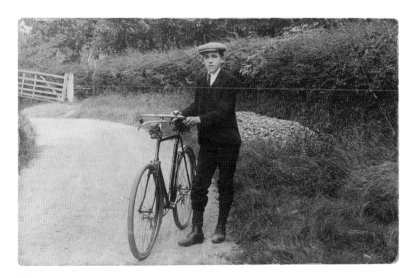

120

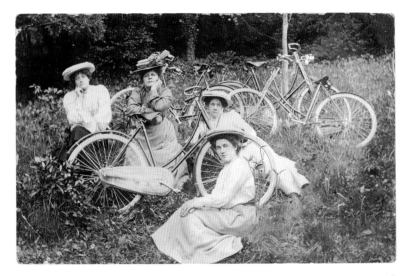

121 1907, Clewe Court, Somerset *

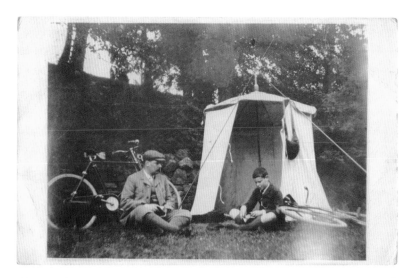

122 1906, Bangor *

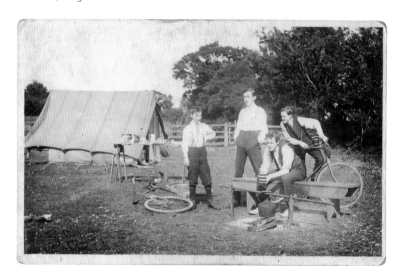

123

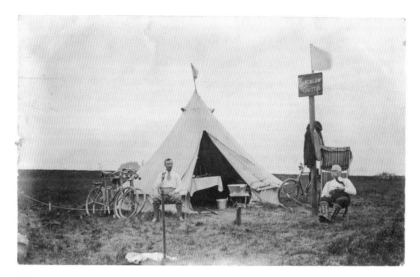

124

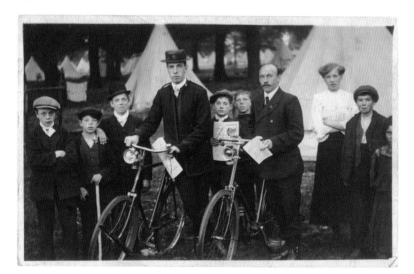

125 1910, Paddock Wood *

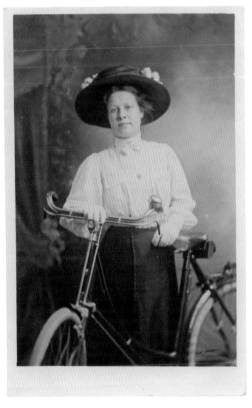

126

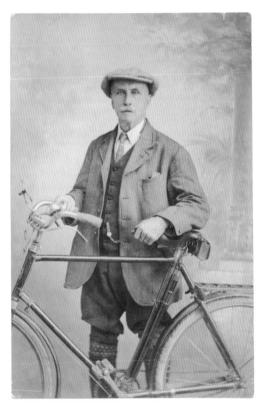

127

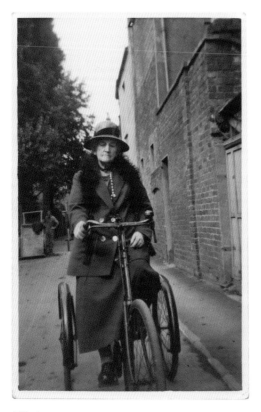

128 Jerome

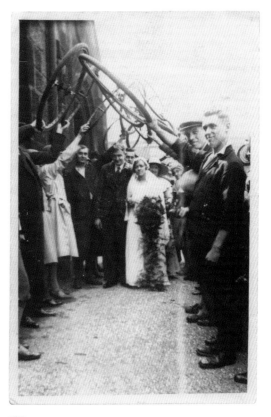

129

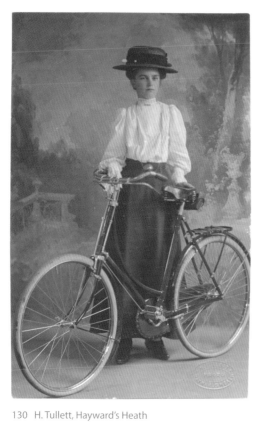

130 H. Tullett, Hayward's Heath

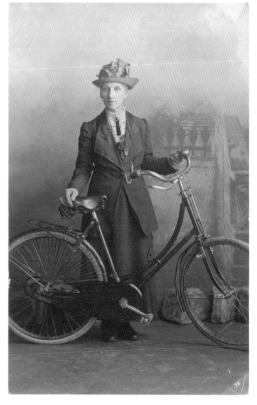

131

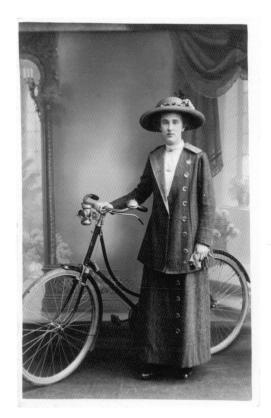

132 F. J. Sheffield, Edmonton

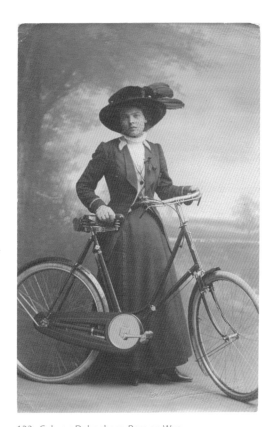

133 Colman Debenham, Ross on Wye

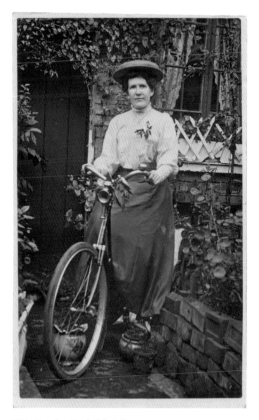

134 Dowley, Rochdale Rd.

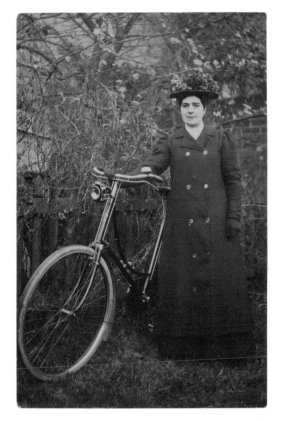

135 *

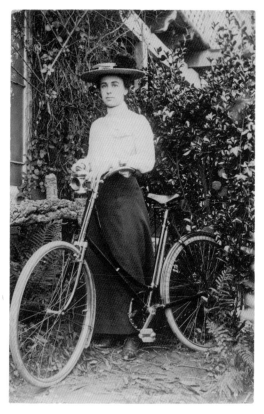

136

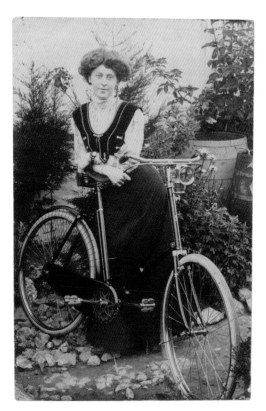

137 1909

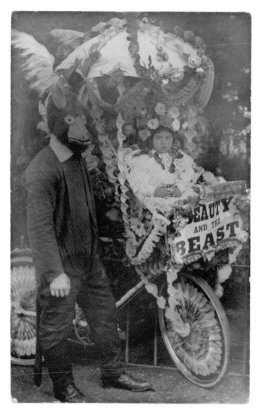

138

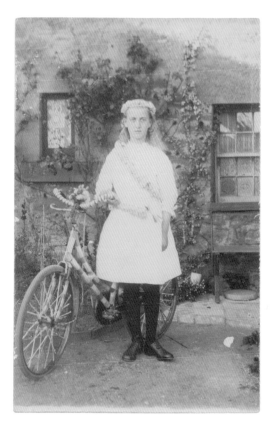

139 Scotland

*

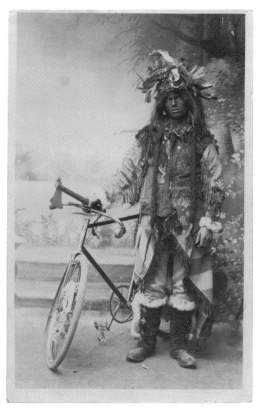

140 Willington, Co. Durham

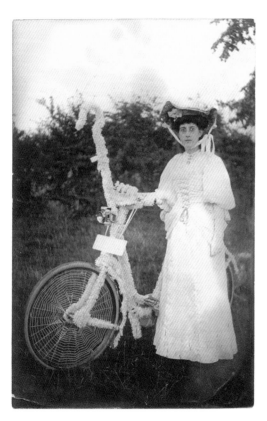

141

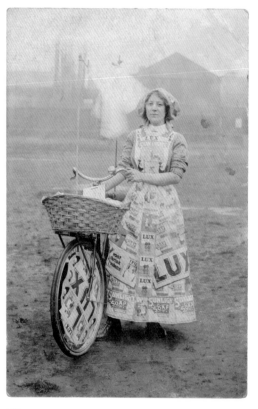

142

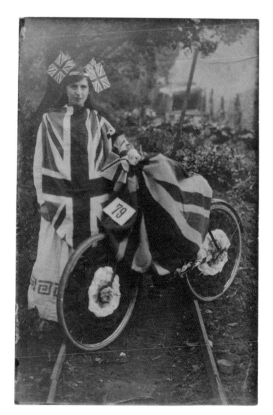

143

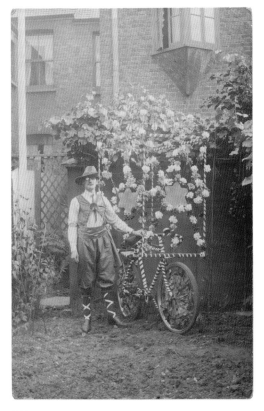

144

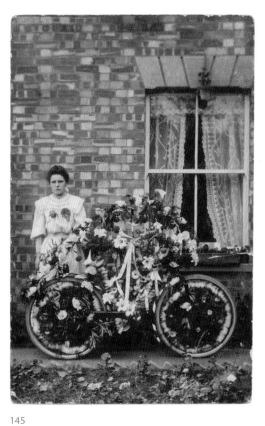

145

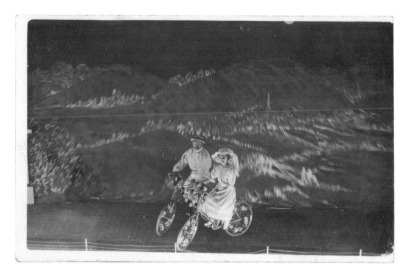

146 London S. E. *

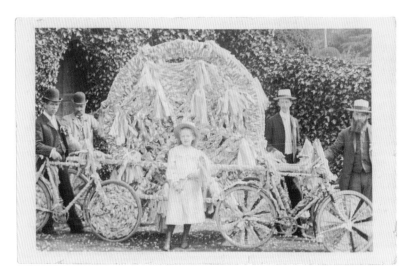

147

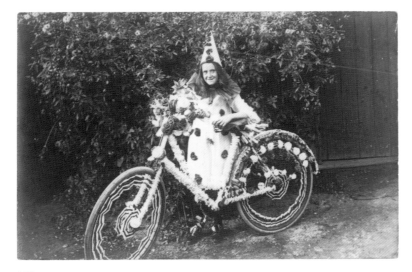

148

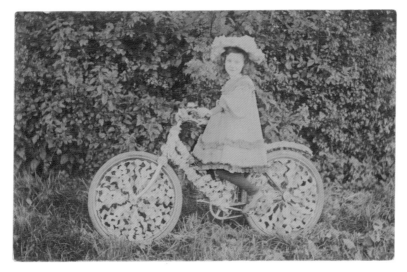

149

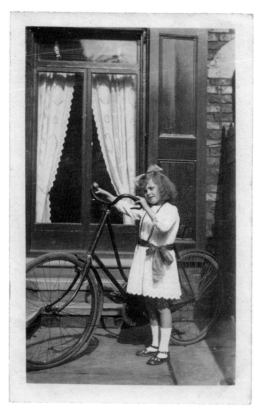

150

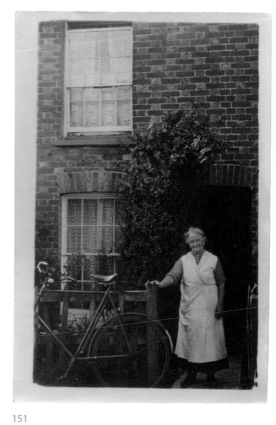

151

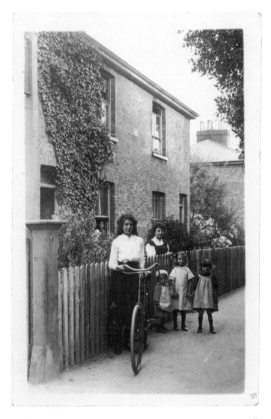

152

*

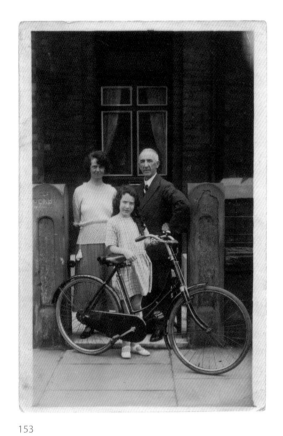

153

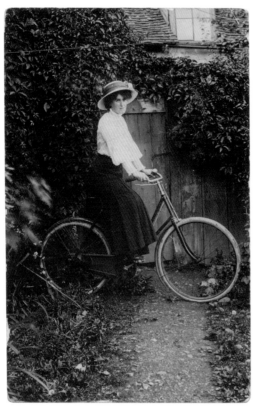

154

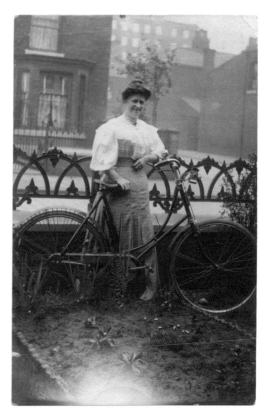

155

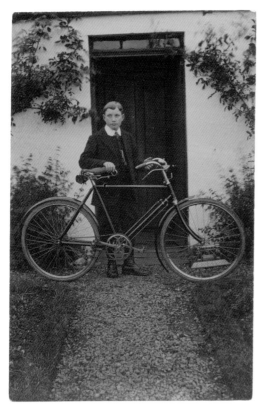

156

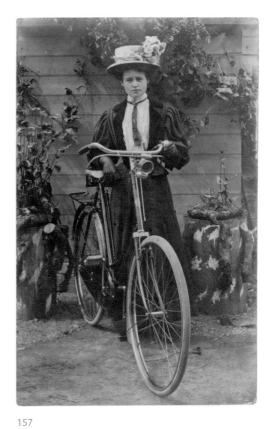

157

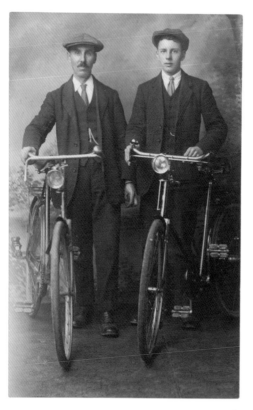

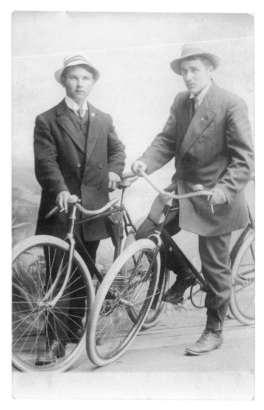

158 1920, Ludlow * 159

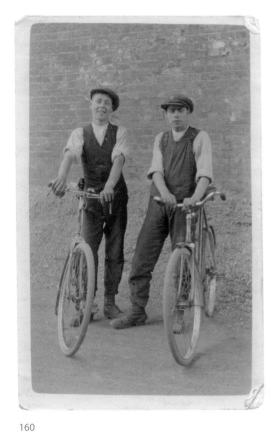

160

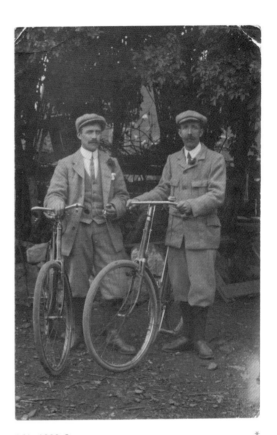

161 1909, Stornoway *

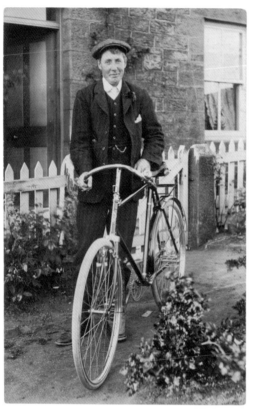

162

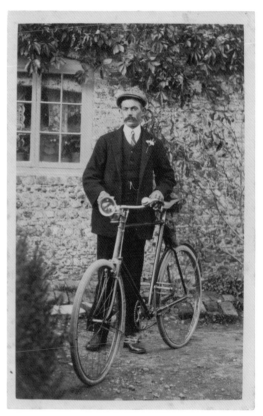

163

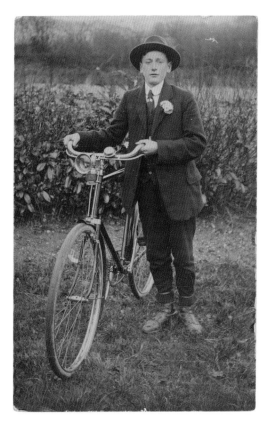

164

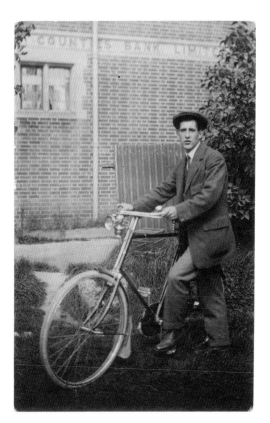

165 1914, Thruxton

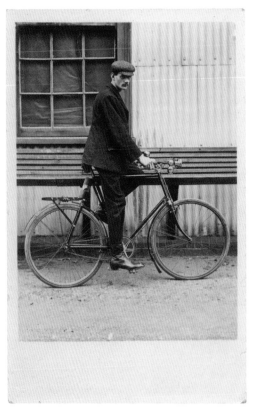

166

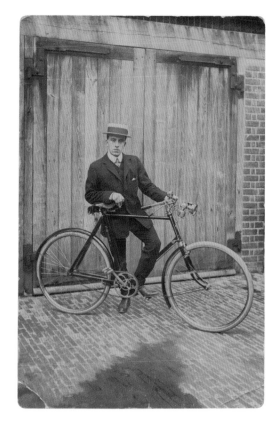

167

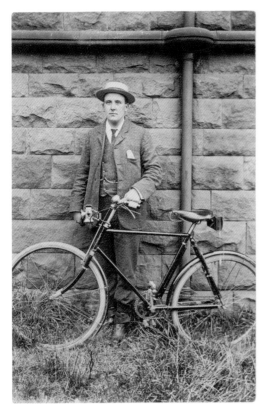

168

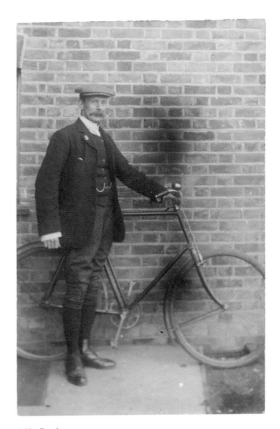

169 Bagby

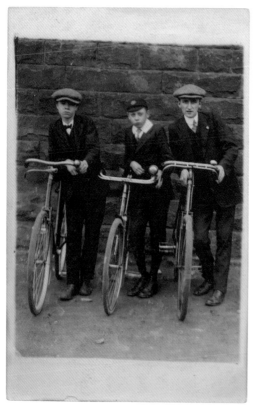

170

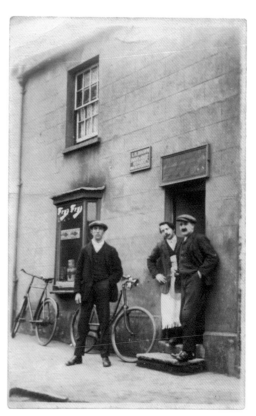

171

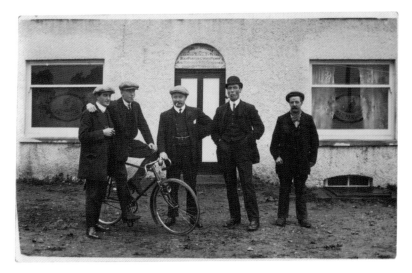

172

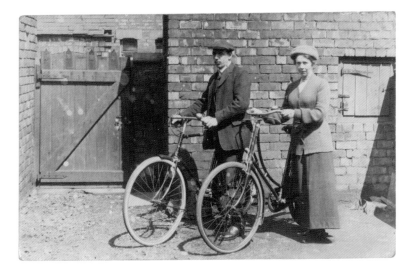

173

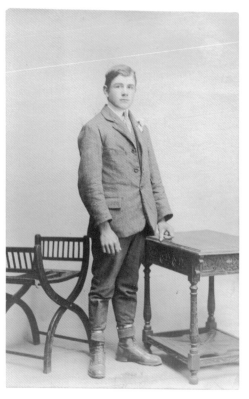

174

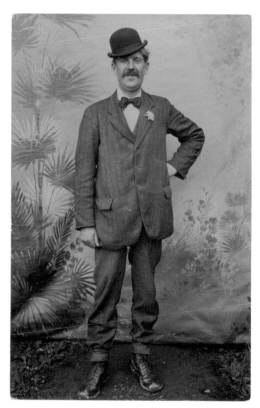

175

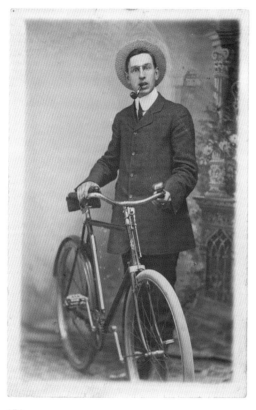

176

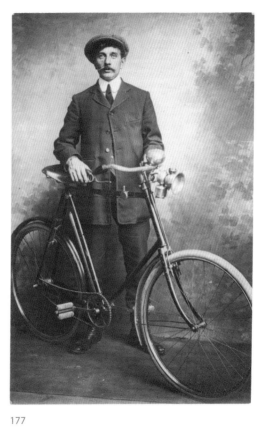

177

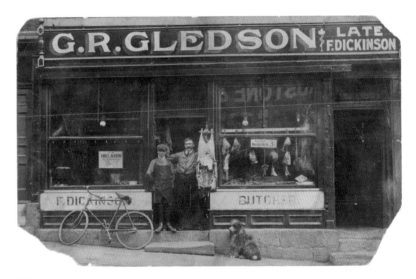

178

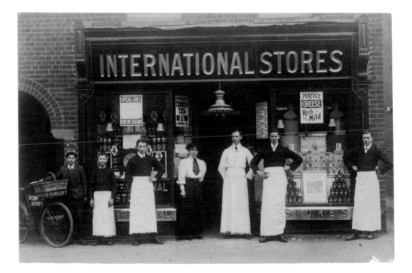

179

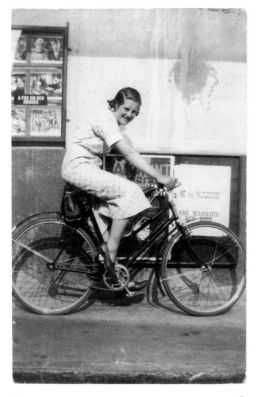

180

*

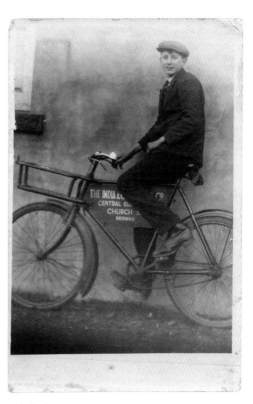

181 Bedwas

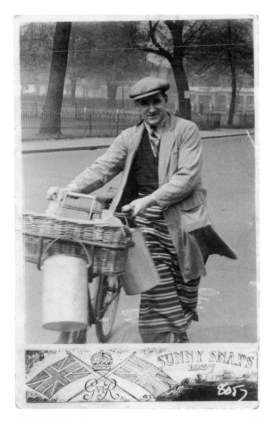

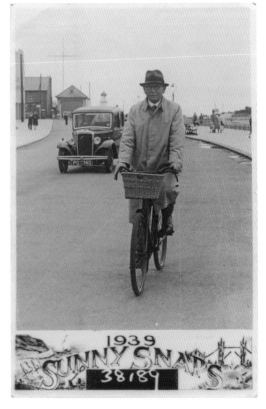

182 1937, Clapham * 183 1939

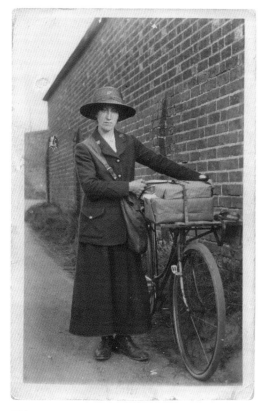

184

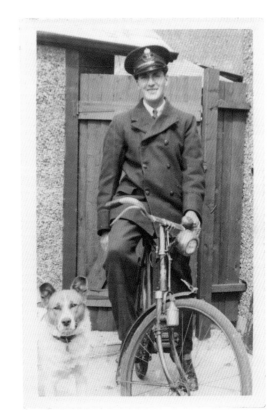

185

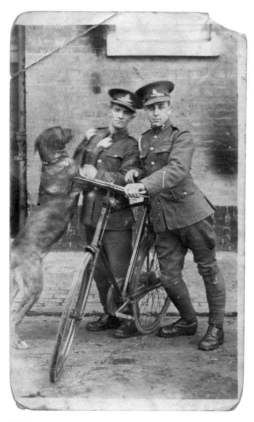

186

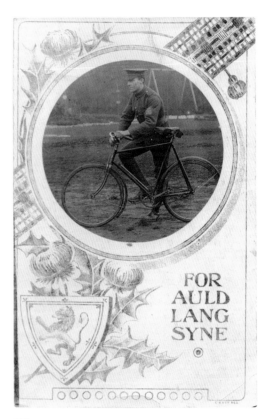

187

FOR
AULD
LANG
SYNE

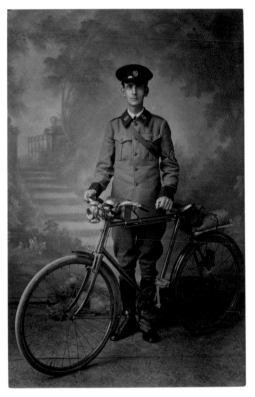

188

189

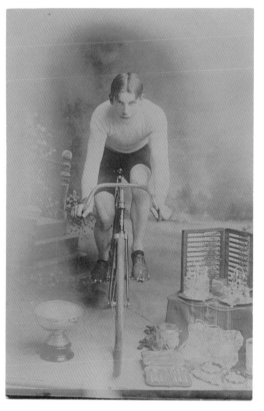

190

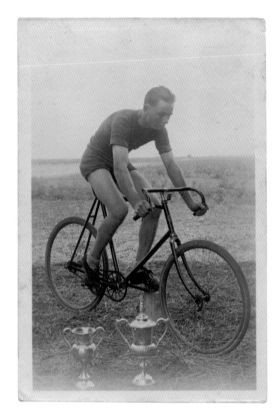

191

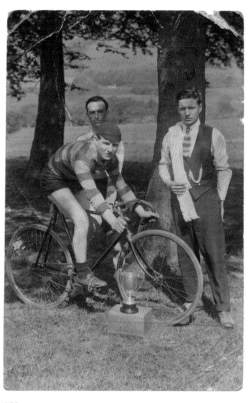

192

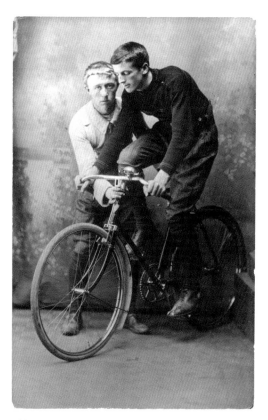

193

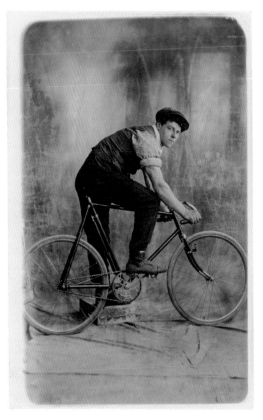

194

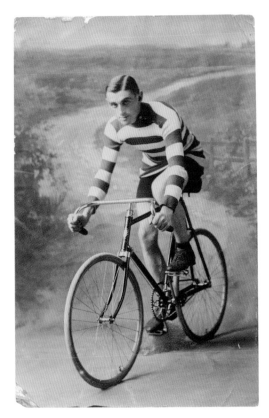

195

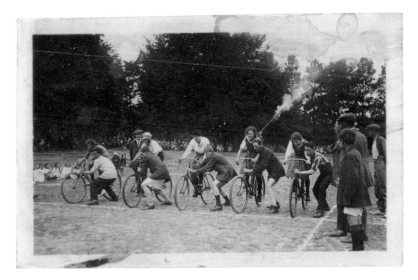

196

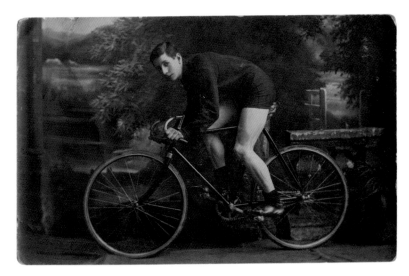

197 R. T. Watson, Hull

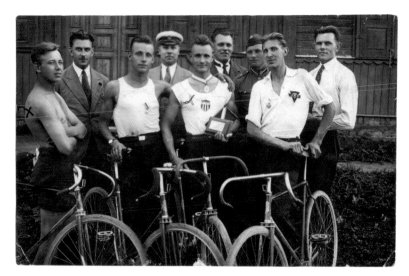

198 1937, India *

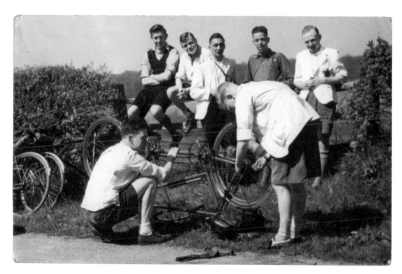

199

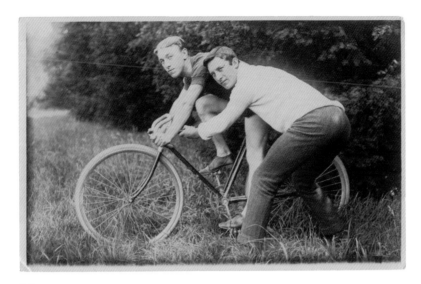

200

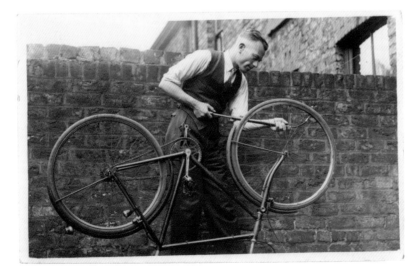

201

GENERAL COMMENTS AND NOTES

To have a portrait made and to possess your own likeness was, for centuries, a luxury that only landed gentry or the mercantile rich could afford. Photography changed all that. Yet a radical democratisation of portraiture had to wait until 1902 when the post office finally allowed messages as well as addresses to appear on the backs of the regulation-sized cards that cost only a halfpenny to post.

You could now go to one of the studios springing up all over the country, pose for your picture, examine the result after a short interval and, approving it, have it replicated for not much more than a penny a card. A supplementary service was offered (at a price) in the form of hand tinting. It seems that statistically Penny Plain was much preferred to Tuppence Coloured.

You might choose, instead of being seen against a neutral background, to be transported via the studio's selection of theatrical backdrops and plaster props to a dwelling of baronial splendour; or to some rural idyll with a view of lake or sea. While factual in appearance the end product (like the painted portrait it evoked) was a servant of dreams. Specialised city studios offered even bolder scenic fantasy, providing costumes and accessories to match. There you, your family and friends could become a troupe of Pierrots, or mimic the Cowboys & Indians of the cinema screen.

A studio's more prosaic outreach included visits to school, office and factory. The local photographer, working street by street, could show you outside your house or shop, or in the privacy of your garden. At church or on the beach he was the inevitable imagist of your wedding or holiday. In effect you could hardly escape him, even by excursion, since no boat trip or charabanc outing was complete without its group photo.

The repertoire was further extended by enthusiastic amateurs: few social gatherings or sporting events were without one ready to record a picnic or winning team. The genre as a whole was in turn radically augmented by the mass produced camera, whose Model T Ford was the Box Brownie. Any local chemist would now be ready to turn your negatives into photo postcards. The snapshot aesthetic introduced a true pictorial vernacular and freed the photograph from imitation of art.

Early in the century the hobby of collecting commercial picture postcards was already well established. Every household boasted an album full of views of places visited, celebrities admired etc. The private photo postcard soon enriched it with an archive of rather more familiar faces. Exchange of such cards became a social ritual. To this we owe the good condition of so many, since they were more often sent in envelopes than posted directly.

So active before, during and after the First World War, the fashion barely survived the Second with its restrictions and austerities. In the late forties only the beach photographer re-emerged. I was last snapped with my parents on a windswept walkway of the Festival of Britain in 1951. My father (who had first been a postcard subject in 1906) failed to buy the result. It seemed to mark the end of the affair.

Photographic portraiture has come full circle: a formal studio portrait is once more a luxury item. Now that our phone, or even toothbrush, can record a more than passable image we are refracted in a kaleidoscope of likenesses.

Many of the largely anonymous people presented here are seen across more than a century, yet it would be wrong merely to view them through the patronising lens of nostalgia. On the contrary they assert and reveal their proper modernity by deportment, style and fashion. Each of their identifiable vintages is the expression, not of a Then, but of a Now that has gone.

N.B. Readers, and especially proofreaders, beware…
As in the texts of ancient civilisations most everyday
writers of this period used punctuation sparely if at all.
My mother (born 1901) never got the habit, though
if she were writing formally, she would sometimes, as
from a pepper mill, scatter a few random dots about.

3 (p2 bottom) 1935, Yorks. *Going to Richmond Meet Whit Saterday 1935.* Gazette

12 To Miss Dearden. *I am sending you one of my photo's. I have had took quite recently. I have (as usual) been to church this morning. I go to Carlton its a village about 3 miles from Worksop. just a nice run, on a fine morning. I have never missed once this summer. ar'nt I good. kind regards from your sincerely. W. Moore*

16 *This is one I had taken on Whit Monday. John P. Coles*

24 To Miss Hetta Hunt in Clayworth, Notts. *Its very good of Nance but does not do me credit… Will*

35 Fred writes to Miss Dickerson. *Just a line as I have not wrote to you for such a time. came through worthing station a few weeks ago should like to seen you but did not know in time*

38 *Alf Dussel Horsham Unity C. C.*

39 *Percy Sharpe & Dorothy Wilde*

42 Sent to Miss Sutton in Gorleston-on-Sea from Edie. *We are sorry to be home again as we had such a splendid time*

43 *To our friends Bill & Lucy from your Lancashire friends Doris & Jack*

44 *Just over the Top of Agony. Coming Back. Albert & Freeman*

45 *Les & myself at Maldon*

48 To Miss Withycombe in Bridgwater. *The nippers are like bits of quicksilver - they are all imagination & anticipation. Their visible world is B'water & Goldfish & Old Tom*

52 Faint inscription on front. *Jack A Faithful Dog*

65 To Miss Allison in Sheffield. *We are realy here can you credit it, oh it is lovely & such a lovely little spot… your mother is looking after Nigger, from colin*

73 *Jas Hall wishes the Bretts 'a guid New Year'*

104 *When we were out on the Salisbury Rd. Age 19yrs*

121 Lill to Mrs. Dean in Clevedon. *Dear Aunty as promised am sending you one of the freak's mind you keep your promise & not smile. I got back in good time tonight. but so tired, the roads are so sticky… let me know what you think of your humble…*

122 To J. M. Cowan in Elgin. *I got one or two doz of these and thought the comedian might like to see it…*

125 One these evangelists writes to Mrs. Chaplin. *Thanks for the p.c. I was surprised to receive it. Another of your little jaunts I suppose… returning to college tomorrow (sat).*

135 Ada to Bess and Lou, Wimblehurst Rd. *I have come to Wish you Merry xmas and New Year when it comes it does not seem true it is so near does it… Sorry to hear you lost your dog. Hope L has got plenty of work getting scarce and there is so much illness about & so many deaths one of Dick Brown's brothers died suddenly in a fit the other week.*

138 *Hope you will like enclosed only came last evening Jack says they are perfect frights but I don't think so…*

146 *The Woodwards, Waterloo Road.*

152 *Dear Auntie Sarah thank you for the handkerchiefs I thought you would like the card better than a Christmas card it isn't a very good photo of me I had just had my hair washed. this is our house. you can just see mother peeping out of the window love to you all including the cats.*

158 *Dad & I taken at Shropshire, when I was about 15 year old.*

161 To Farnham. *will you know this two. We were on a Grand excursion in Stornoway a week ago and got these taken.*

180 Inscribed *Outside Gaumont British*

182 Jim Morgan to Rev. & Mrs. Richards, Kings Lynn. *Sent parcel per McVitie hope it came in good time.*

198 *Thanks for your letter with the stamps. Hope you liked the F. D. cover of India… Fix all stamps of Ceylon on one strong cover like mine. For Rs 2/- send 20 mint sets of 3 low values of K. G. VI with the F. D. C.*

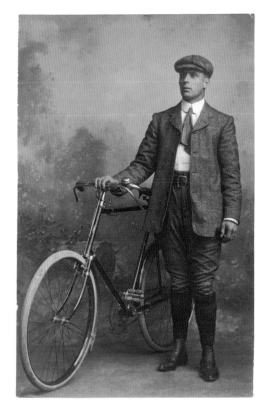

202 H. Bentley, Barrow in Furness

How in the Devil are you and Tom getting on I thought I
would send this to hurry you up a bit with that letter you
never wrote. I hope you and Tom are behaving yourselves
and don't be in the same fix when I down that way again.
Tom got quite famous with his Plough. I saw his photo
in the Papers here. I suppose you will soon be having
Mary down that way again. I won't be responsible for my
actions, next time I catch you two in Bed. with love Geo